T0258650

THE SEDUCTION Of ALMIGHTY GOD

Howard Barker

THE SEDUCTION OF ALMIGHTY GOD

BY THE BOY PRIEST LOFTUS IN THE ABBEY OF CALCETTO, 1539

OBERON BOOKS
LONDON

First published in 2006 by Oberon Books Ltd
521 Caledonian Road, London N7 9RH
Tel: 020 7607 3637 / Fax: 020 7607 3629
e-mail: info@oberonbooks.com
www.oberonbooks.com

A catalogue record for this book is available from the British Library.

Cover image: Eduardo Houth

ISBN: 1 84002 711 8 / 978-1-84002-711-2

Characters

LOFTUS, a Boy

RAGMAN, an Abbot

PENGE, a Priest

SHELF, a Female Baker

VOLUME, Mother to Loftus

COOTER, a Priest

BOX, an Official

FELLOW, Wife to Box

EXX, a Labourer

FIRST INTRUDER, male

SECOND INTRUDER, male

COTTON, an Official

BATH, Wife to Cotton

BIRO, an Insurance Man

NAPE, Wife to Biro

The Seduction of Almighty God was first performed by The Wrestling School at The Door, Birmingham Rep on 2 November 2006 with the following cast:

LOFTUS, Leander Deeny

RAGMAN / BIRO, Peter Marinker

PENGE / BOX, Christian Bradley

SHELF / BATH, Judith Siboni

VOLUME / NAPE, Miranda Cook

COOTER / FIRST INTRUDER, Christian Pageault

FELLOW, Caroline Corrie

EXX / SECOND INTRUDER / COTTON, Philip Sheppard

Director, Guillaume Dujardin

Designer, Tomas Leipzig

The Exordium

A vast stone floor. A youth waits.

Scene 1

A figure holding an umbrella emerges from the obscurity. He observes the youth from a distance. A massive bell tolls, its sonority filling the stage. It ceases.

RAGMAN: Still here?
How utterly contemptible to wait so patiently when it
must have been perfectly obvious you had been forgotten
perhaps you have no self-esteem some don't some crawl
over the earth not daring to lift their eyes to meet the
withering regard of others
Still here?
There comes a point surely when patience ceases to be
experienced as virtue even by him who possesses it in
such abundance and is revealed instead as weakness a
stain on the character you are perhaps not patient at all but
burdened with a servile disposition possibly so craven you
entertain the sordid hope we will admire you
Still here?
Admire you for what I watched you as I ate my breakfast
masticating slowly each mouthful forty times before
I swallowed swirling my drink in the glass scratching
yawning idly manoeuvring the cutlery and I thought I
uttered I said out loud the youth is bullock-brained the
youth is trough-intelligent ordure not blood travels down
his veins and it was raining you looked absurd a sheep's
abortion washed into a drain
Still here?
(*RAGMAN lowers his umbrella. He observes the youth intently.
The youth half-smiles, biting his lip.*)
LOFTUS: This testing of me
RAGMAN: Testing?
LOFTUS: This ordeal by abuse
RAGMAN: Abuse?

I am describing you
You repudiate the description it does not follow the
description is abuse
Oh
Oh
I'm tired
Tired of my own brain
GO AWAY THERE'S NOTHING FOR YOU HERE
(*He turns to go.*)
LOFTUS: SHELTER MY FAITH
(*RAGMAN stops.*)
Or does it embarrass you?
(*RAGMAN ponders.*)
Don't be embarrassed by my faith
(*Pause. RAGMAN turns at last.*)
RAGMAN: You are a prig
And a poseur
And all you want's a room
(*Pause. LOFTUS is unflinching.*)
LOFTUS: The same was said of Christ
And yes I want a room
RAGMAN: A room for what?
LOFTUS: To argue with the angels in
RAGMAN: ARGUE WITH THE ANGELS IN YOUR FATHER'S
HOUSE
LOFTUS: This is my father's house
RAGMAN: YOUR DAD'S
YOUR DAD'S I MEAN
LOFTUS: He has too many children
RAGMAN: Is that so?
LOFTUS: And the noise inhibits contemplation
RAGMAN: Too bad
LOFTUS: Not only the noise
The noise I think I might reach an accommodation with
But they mock my faith
(*Pause. LOFTUS looks intently at RAGMAN… A monk on a
bicycle makes a leisurely, circuitous journey over the stage. He
disappears into the obscurity…*)

RAGMAN: Originally we slept in dormitories
 Twenty
 Thirty to a room
 (*Pause.*)
 If sleep's the word
 And every other hour prayers
 Cold floor
 The winter reaching underneath the door
 And knees
 Imagine it
 Knees are not made to crouch so
 Bone's not stone
 Four in the morning
 February
 Damp
 Oh
 (*RAGMAN shakes his head. His eyes remain fixed on LOFTUS.*)
LOFTUS: What are knees made for, then?
 (*Pause.*)
RAGMAN: You're ill
 (*Pause.*)
LOFTUS: I don't feel ill
RAGMAN: You don't feel it
 No
 It's not that sort of illness
 (*Pause.*)
LOFTUS: It's an illness I can't feel?
 (*Pause.*)
RAGMAN: Paradoxically it's an illness that makes you confident
 you are in perfect health
 (*Pause.*)
 All the same the symptoms are very plain to see
 (*Pause.*)
LOFTUS: What symptoms are these?
 (*Pause.*)
 I feel I have offended you in some way and I only came
 here to
RAGMAN: ONLY CAME HERE
 ONLY CAME HERE

WHINE ON
HOW CRUEL LIFE'S BEEN TO YOU
WHINE ON
I don't wish to be unkind to you
Who are you anyway
A pale-eyed youth
An utter stranger
And what a lovely day
The rain hurried away to fall on harbours and in estuaries
That's surely the proper place for rain
Do you like flowers
Does your mother
Take some as you go
Poor woman
All those children
Snotty
Quarrelsome
Wiping this one
Feeding that
Show your love for her
The towering delphiniums are nice
(*Pause. For the first time LOFTUS begins to laugh. At the same moment, the cyclist returns with a basket of loaves.*)

LOFTUS: He says I'm ill

PENGE: And are you?

LOFTUS: Of course not and if I were it would be God's will would it not why don't you bake your own bread?
(*Pause. PENGE climbs off the bike.*)

PENGE: The bakehouse has no roof now and there are rather few of us
(*He smiles complacently.*)
Besides which
(*He casts a glance at RAGMAN.*)
It gives employment to a woman in the village
(*He looks critically at LOFTUS.*)
This woman is gifted
Not only in bakery
All things rise for her
All

Things
(*Pause. He looks boldly at LOFTUS.*)

LOFTUS: Yes

(*LOFTUS shifts uncomfortably.*)

Yes

(*He slowly collapses to the ground. His limbs are pulled as if by cords into a tight knot and then expand again. He rolls. A faint whine, as if an argument were occurring in his brain, comes from the writhing body. The priests watch, bewildered. LOFTUS becomes still. He sits up. He looks vacantly at them.*)

I am ill

(*A pause, then RAGMAN rushes and takes the boy in his arms.*)

DON'T RETURN ME TO MY MOTHER

RAGMAN: When I

When I said

In a sort of temper

Spitefully

Hatefully

That you were sick

I meant only this

You are not modern

(*Pause.*)

Everything about you

(*Pause.*)

Speaks of another age

(*He shrugs.*)

This I called an illness

(*He squirms.*)

In fact it's beautiful there are rooms here any fool knows that dusty damp mice rats I don't know ask him I don't go near them the sewage has collapsed

(*He walks away. PENGE observes LOFTUS without speaking for a long time.*)

PENGE: It's you and God, is it?

In the deep dark valley what's your name

LOFTUS: Loftus

PENGE: Loftus clamouring for God

The rooks

The frost

Loftus tossing on the cot
There is one nice room it's on the landing dry and with
a little basin but you wouldn't want that it doesn't have
the necessary elements of discomfort you aspire to try the
one above the hospital it isn't anymore a hospital it's let
out as a wagon store it's thoroughly decrepit and what's
more a good half-mile from the chapel imagine that on icy
mornings exactly what the Loftus craves to bring him near
to God you are going barefoot I assume
(*He smiles at LOFTUS. Pause.*)
God can't be bought
(*Pause.*)
By scourging
(*Pause.*)
Solitude
(*Pause.*)
Or fasting
(*Pause.*)
I'm afraid
(*PENGE climbs onto his bicycle.*)
He's in gems and silver
Furs
Stockings
And
Cunt
Too
(*He pedals away. LOFTUS is perfectly still for some time.*)
LOFTUS: I disagree
(*He bites his lip.*)
Albeit God created cunt
(*Pause.*)
As you choose to describe it
(*Pause.*)
That is not his habitation
(*An old woman appears. LOFTUS senses rather than observes her
presence. She tosses a pair of socks, which lands at his feet. LOFTUS
looks down.*)
I don't wear socks
VOLUME: You don't wear socks?

LOFTUS: Did Christ?

VOLUME: I don't know about Christ it's you who knows about Christ

LOFTUS: He did not wear socks

VOLUME: Put them in a drawer

LOFTUS: I don't have drawers

VOLUME: No drawers?

LOFTUS: Why should I need drawers when I have no possessions?

VOLUME: To put socks in

LOFTUS: Listen

VOLUME: Socks and vests

LOFTUS: Listen to me

VOLUME: They're not possessions

LOFTUS: I have ended one life

VOLUME: Are they socks and vests I don't call them possessions

LOFTUS: ENDED ONE LIFE AND BEGUN ANOTHER
(*Pause.*)

VOLUME: That's why I brought the socks
(*Pause.*)
You can't come back
(*Pause.*)
Nobody wants you
(*Pause.*)
The socks was cheerio
Dear boy
(*They stare at one another. Suddenly VOLUME clasps LOFTUS in her arms.*)

Scene 2

The noise of demolition. Clouds of drifting dust pass behind high windows. A cot is drawn over the stage in which RAGMAN lies propped on pillows. It stops. A woman carrying a basket of bread passes in the opposite direction. She stops, and with one hand lifts her dress, exposing her belly to RAGMAN. At once she lets it fall and continues her journey.

LOFTUS: That doesn't help

(*She ignores him.*)

Absurd

(*He shrugs.*)

Absurd and mischievous

(*She goes out. RAGMAN lets out a wail of despair.*)

Yes

Yes

She thinks she can distract you

She thinks her paltry nakedness can turn your mind from
its titanic struggle

(*He wails again.*)

Yes

I do believe she considered it a gift

RAGMAN: OH, TELL ME I'M NOT DYING

LOFTUS: I can't

I can't tell you you're not dying

RAGMAN: SAY IT

(*He grasps LOFTUS by the wrist.*)

Saying it will give me strength

(*Pause. LOFTUS looks into RAGMAN's face.*)

LOFTUS: Is that true?

Hearing what is spoken only to gratify you

What is said not from the heart but from the mouth

What is coerced

That will give you strength?

(*RAGMAN nods affirmatively. LOFTUS writhes.*)

No

No it smears both of us

RAGMAN: OH, TELL ME I'M NOT DYING

LOFTUS: (*Pulling away from RAGMAN.*)

I'm only seventeen

Why have I been left to

Where is Michael

Where is Anthony

(*He turns on his heel.*)

No

No

It is a privilege

God honours me

God endows me with the ecstasy of walking with you to the
door of death
(*RAGMAN wails. LOFTUS seizes his hands.*)
Pray
Pray
RAGMAN: I HAVEN'T FINISHED WITH THIS PLACE
LOFTUS: Inevitably it seems the moment of our going is not
correct
As if God
Distracted for a moment
Had made a slip
As if exhausted with his labours as He is
He plucked us out at random
(*RAGMAN heaves.*)
No
Never
Never is He random
(*RAGMAN surges.*)
MY ARM
YOU
(*LOFTUS flings away RAGMAN's terrible grip.*)
Oh
Oh
Run to His love
(*He is dimly aware of a figure watching from a corner.*)
PENGE: You don't believe that
(*Pause.*)
Any of that
(*Pause.*)
Stuff
(*He walks away slowly to the bed.*)
Respect the man's intelligence
(*He sits on it.*)
Give him a bit of truth
(*Pause. PENGE adjusts RAGMAN's blankets.*)
LOFTUS: Perhaps he doesn't want the truth
(*Pause.*)
Perhaps you are yourself less interested in the truth than
PENGE: Shut up

LOFTUS: Than inflicting your sordid cynicism on a man who is too helpless

PENGE: Shut up I said

LOFTUS: And too bereft of faith to yield himself to the supreme love of the Father

PENGE: What do you know about love?

LOFTUS: Which is the reward of Death and

PENGE: What do you know about death?

LOFTUS: I HATE YOU

I HATE AND SHRINK FROM YOU

PENGE: Good

(The woman with the basket saunters in. The basket is empty.)
Hello darling
(Before the woman can reply, LOFTUS springs at PENGE and seizing him round the throat, drags him off the bed.)

LOFTUS: DON'T DARE

DON'T DARE TO

(They struggle.)

CONTAMINATE THIS ROOM WITH

(PENGE is naturally stronger than LOFTUS, but LOFTUS is wild, endowed with demonic energy.)

SHELF: Hey

Hey

LOFTUS: *(Throttling PENGE.)* YOU VILE

SHELF: *(Chucking down her basket.)* Hey you barmy

(She goes to intervene but RAGMAN grabs her wrist.)

RAGMAN: OH, TELL ME I'M NOT DYING

SHELF: Help

(LOFTUS has mastered PENGE and slaps him around the face again and again.)

Oh don't

Oh don't do that

(SHELF frees herself from RAGMAN's clutch and goes to pull LOFTUS away. LOFTUS smacks her. She shrieks, covers her face with her hands. LOFTUS lurches away, goes to RAGMAN.)

LOFTUS: Oh dear man

The words

I cannot find the words

(*LOFTUS sobs, clasping RAGMAN's hands.*)

I only know the meaning

(*Pause. The sounds of demolition are unabated, but in the room, all is still. LOFTUS recovers. He peers at RAGMAN.*)

RAGMAN: I feel stronger

(*LOFTUS is puzzled to see RAGMAN haul himself up on his pillows.*)

From

God

Knows

Where

(*He lets out a strange half-laugh, half-sob.*)

STRENGTH

(*He laughs loud. LOFTUS recoils from the bed. His gaze falls on SHELF, whose finger indicates the still form of PENGE. RAGMAN throws back the blankets.*)

Look at me

(*He swings his legs out. He stands. He totters a moment.*)

No pain

No thirst

(*Neither SHELF nor LOFTUS heed him, but stare fixedly at PENGE's lifeless body.*)

QUITE

OBVIOUSLY

DELIVERANCE

(*He turns, kneels at the bed and prays fervently.*)

Father

Father

Thou hast lifted from me the burden of my sins

(*He sobs feebly into the bedclothes.*)

LOFTUS: (*Turning to RAGMAN.*) Something terrible has happened
 to Michael

(*SHELF utters a stifled shriek.*)

RAGMAN: I feel like eating

LOFTUS: Michael has

 For some reason

 Michael's

RAGMAN: (*Looking at LOFTUS.*) And not a sandwich

No

A dinner

LOFTUS: Would you look at Michael I

RAGMAN: A FOUR COURSE DINNER

(*RAGMAN cannot help laughing.*)

What have I done to deserve this miracle?

LOFTUS: Let's come back to you in a minute

SHELF: You didn't mean to

LOFTUS: No

SHELF: You didn't it was oh a sudden such a sudden and you
slapped me

LOFTUS: Did I slap you

SHELF: Slapped me and then you oh shaking him and then
you such a hard slap nearly knocked my teeth out I thought
what's come over him eyes all staring but you didn't mean
to my jaw went smack I saw stars I thought he doesn't mean
it proper stars yellow blue what a wicked slap that was
perhaps he isn't dead perhaps he only fainted

LOFTUS: No

He is dead

And I did mean it

(*RAGMAN stares at LOFTUS.*)

He was barbaric

And it's proper that he's dead

(*SHELF also stares... A long pause.*)

This

(*He bites his lip.*)

This

Satisfaction that I feel

Is

I know

Incompatible with the teaching of Christ

(*Suddenly he falls and thrashes about, watched by SHELF and
RAGMAN, helpless and alarmed. At last his motions cease. He lies
perfectly still on his back.*)

RAGMAN: Hankering for beef stew

(*SHELF turns to the old man.*)

If you would be so

(*Pause.*)
Carrots
Turnips
Onion
Etcetera
(*SHELF sets off.*)
And hush
(*She stops, looks back.*)
Hush about Michael
(*Pause, then she leaves the room. A pause, then he speaks urgently, as if afraid.*)
EXPLAIN THIS
WHAT IS THIS
I'M ALL
LOFTUS: (*Still on his back.*) Shh
RAGMAN: SHH YOU SAY BUT WHAT EXACTLY
LOFTUS: Shh
 Shh
RAGMAN: I'M ALL
 LOOK AT ME
 NEVER HAD MORE LIFE IN ME I CAN'T KEEP STILL
 WHAT ARE YOU
LOFTUS: I don't know what I am
RAGMAN: YOU DO
 YOU DO KNOW
 INCUBUS
 I WAS DYING
 DYING IN THE ARMS OF CHRIST AND
 (*He lifts his hands in horror.*)
 I HAVE TO WALK ABOUT
 (*He paces round the room, in an excess of physical strength.*)
 And you
 You whom I admitted out of
 PITY WAS IT
 YOU DRAGGED ME BACK TO THIS
 (*He flings himself on the bed.*)
 Oh
 Oh

Everything about you is so
So
I RESENT YOU PROFOUNDLY AS I THINK YOU KNOW
(*They both lie still. The sounds of demolition.*)
LOFTUS: (*At last.*) How much are they paying?
(*RAGMAN declines to reply.*)
The builders?
The demolitionists?
For our red sandstone?
(*RAGMAN looks at LOFTUS, coolly, objectively.*)
Hugely, I imagine?
(*Pause. He looks back.*)
And the noise
The dirt
It's impossible to pray
(*Pause. Their eyes lock in a contest.*)
RAGMAN: A brother
LOFTUS: Yes
RAGMAN: A brother lies dead
LOFTUS: Brother Michael
RAGMAN: BY YOUR HAND
(*Pause.*)
And you
You
Turn your mind to
LOFTUS: It was Brother Michael I was thinking of
(*Pause.*)
Him it was I think
(*He smiles.*)
Michael did the contracts I understand
(*A pause of strain and repressed anger precedes RAGMAN leaping off the bed and running round the room to relieve his surplus energy. He stops on a spot.*)
RAGMAN: Loftus
The refectory
The huge and entirely superfluous refectory
Built for two hundred monks and anyway in a state of disrepair

Was

Embarrassing

Redundant

And

LOFTUS: An asset?

RAGMAN: The abbey occupies one hundred acres and there
are only half a dozen clerics here

LET'S BURY HIM IN THE

LOFTUS: WHO CARES ABOUT THE ACREAGE

(*He glares now at RAGMAN.*)

Who cares if Christ is an embarrassment to you?

(*Pause.*)

Yes

Put him in the well

RAGMAN: Well?

LOFTUS: THE REFECTORY IS ALSO CHRIST'S

The well

Yes

Why not the well?

RAGMAN: All right

LOFTUS: Say he went off

RAGMAN: Cycling

LOFTUS: Cycling

RAGMAN: He cycled everywhere

He did

I'll pray for him

We both will

I WISH I COULD KEEP STILL

(*He clasps himself.*)

Scene 3

*Silence. A monk enters. He stands alone. Suddenly he falls on the ground
and rolls, kicking his legs in the air. Laughter trickles from an unseen
observer. The monk ceases his mockery and lies on his back laughing.
SHELF enters.*

SHELF: It's not like that

COOTER: It is like that

SHELF: If he saw you

COOTER: IF HE SAW ME
 What would he do if he saw me
 Let him see me

SHELF: Something terrible

COOTER: What
 What terrible
 (*He jumps up, energetically.*)

SHELF: He's God's

COOTER: (*Mimicking her.*) He's God's
 I'M GOD'S
 YOU'RE GOD'S

SHELF: Not like Loftus

COOTER: HE'S NOT MORE GOD'S THAN ME
 (*He glares. He tries to calm himself.*)
 I am bored and sick with his demeanour
 His silence
 His pedantry
 Bored and sick also with your adulation of it

SHELF: Be careful

COOTER: Be careful why
 And I know the source of it

SHELF: Be careful, Anthony

COOTER: BE CAREFUL WHY
 The source is simply this
 THE BOY WON'T FUCK

SHELF: Shh

COOTER: Oh yes
 Women
 Oh they love the man who won't
 The man who could if
 Would if
 Only if
 I know women
 You make me sick the lot of you

SHELF: Anthony

COOTER: I've a mind to get a bicycle

SHELF: Kiss me

COOTER: And pedal it and pedal it in one direction pedal it
 until my knees gave out like Michael did presumably and
 say here here where my pedalling stopped here I'll make
 my life I dislike it here
SHELF: Kiss me
COOTER: I dislike it now
 It's all so
 (*He shrugs.*)
 AGONIZED
 And you kiss everybody what's a kiss from you
SHELF: I'm sorry
COOTER: What's it worth your kissing?
SHELF: I don't know
 Not much
 Not much I suppose
COOTER: Nothing at all
 It was so excellent here once
 We all
 Didn't we
 We all
 (*Pause. He rubs his cheek thoughtfully.*)
 He has introduced something
 Something which was
 Which we
 Successfully ignored or rather felt we had abolished
 Something terrible and yet
 I can't say what it is
 But certainly it comes from him and I
RAGMAN: (*Entering.*) SCRUTINY?
 (*They turn to RAGMAN.*)
COOTER: Is that what it is
 Yes
 Scrutiny
 One's every action is somehow impeded
 What used to be spontaneous you find yourself
 Everything is
 I've stiffened
 I've started to

(*Pause. He lifts hands.*)
Scrutinizing yes
RAGMAN: (*His hands folded in front of him.*)
Don't stay, Anthony
(*COOTER looks in disbelief.*)
COOTER: Don't stay?
(*RAGMAN looks at the floor.*)
Don't stay?
(*He looks to SHELF.*)
Did he say
SHELF: I don't know what he said
COOTER: (*To RAGMAN.*) I AM A BROTHER OF THIS ORDER AND I
RAGMAN: Yes
(*He looks coolly at COOTER.*)
But God has lifted his hand from you
(*Pause.*)
COOTER: That's his phrase
Pure Loftus
Rhetorical
Obscure
Why should I leave
I like it here
She'd go mental for a start
Would God like that
TWO MONKS IN THIS PLACE
Funny if it weren't so sad
AND WHO EXACTLY WOULD HANDLE THE TENANCIES
The peasants they can talk to me
I'm fair but firm
Whereas you
With all respect
You
Look
She's crying
A woman crying
God's hand
Bollocks
RAGMAN: I am the abbot, Michael

COOTER: Are you

Are you the abbot though

RAGMAN: THE ABBOT AND THIS IS UNFORGIVABLE

(*A long pause. COOTER seems to sink a little inside his shoulders.*)

COOTER: I

Oh dear

I'm crying now

I have found life so perfect here I

It's true

I have discarded

God

(*LOFTUS enters. He hears the note of confession and is immediately still.*)

Or rather

For my own convenience

Put God in places where He could never contradict me

Made Him mineral

And inert

Landscape

Gardens

Pools

(*He laughs, shaking his head.*)

As if God were some benevolence who as long as I was

happy would be happy too

A Mother

(*He laughs again. He sees LOFTUS. He fixes him with his gaze.*)

When God's Lord

And every day

CLAMOURS

(*RAGMAN, SHELF, look at COOTER.*)

BOOMS

SHAKES THE DOORS OF OUR INSUBSTANTIAL DWELLING

(*Pause.*)

Is that not right, Loftus?

God is a blizzard

In which it's hard to keep erect?

(*LOFTUS advances further into the room. COOTER falls at his feet
and kisses the hem of his garment...*)

LOFTUS: Does it please you to deceive me?

COOTER: I'm not deceiving you
 (Pause.)
LOFTUS: After all
 To be deceived is not a sign of foolishness
 No shame attaches to it
 Whereas you
COOTER: I'm not deceiving you
 (Pause. LOFTUS walks away, stops.)
LOFTUS: I think so often of deceit
 Believe me
 It is the subject I have pondered more than any other
COOTER: Yes
LOFTUS: It plagues us
 It describes us
 Possibly our whole existence is contingent on deceit
COOTER: Yes
 I have sometimes wondered that myself
LOFTUS: Good
 Now you must quit
 As Abbot Ragman says
COOTER: QUIT
LOFTUS: Yes at once
COOTER: YOU QUIT
 (He scrambles to his feet.)
RAGMAN: Oh
COOTER: Yes
 Why me
 Eight years I've
SHELF: Shh
COOTER: Eight years
RAGMAN: Oh
COOTER: And he
 A NOVICE
 He
SHELF: Shh
 Shh
COOTER: It's
 Really

It's preposterous
I'm not angry

SHELF: Shh

COOTER: Susan, I am not angry
I am simple saying
I say this
Simply
And
Unambiguously
I do not intend to submit to this unjustified and
Anyway where should I go?
(*He looks to RAGMAN, who shrugs, but whose shrug is cut short by LOFTUS.*)

LOFTUS: Jerusalem
(*A dark pause.*)

COOTER: Jerusalem

LOFTUS: Have you been to

COOTER: It's thirty years since anyone went to Jerusalem
(*LOFTUS merely looks at COOTER.*)
Which is perhaps
(*Pause.*)
Arguably that is a reason for
(*He calculates swiftly.*)
I'll go to Jerusalem if you will
(*Pause.*)

LOFTUS: You see
You are so inundated with the practice of deceit the
stratagem is always your first recourse it is an instinct
with you Anthony I said Jerusalem not to discomfort you
but to remind you of the value and the obligation of the
pilgrimage and you in your turn far from finding in this
your way back to God employ Jerusalem to embarrass me

COOTER: No
No
I

LOFTUS: Yes it's undeniable and

COOTER: ALL RIGHT YES
(*He hangs his head. His teeth grind, his fists open and close.
LOFTUS allows him to suffer.*)

27

I can't face Jerusalem
I can't face anything
I want to stay here
Susan
Me
We
Little patch of vegetables up the lane
Sweet hours we
(*Seeing* COOTER *disintegrate,* SHELF's *hand goes to her mouth.*)
She puts flowers in my cell
(*He sobs violently.*)
Loftus
Loftus
Let me stay
(COOTER *is a pitiful spectacle from which* RAGMAN *averts his eyes.*)
SHELF: (*As if inspired.*) I AM AN EVIL WOMAN
RAGMAN: Shh
SHELF: EVIL AND
RAGMAN: Shh
 Shh
LOFTUS: No
 Let her speak
SHELF: A husband and two lovely children
LOFTUS: Yes
SHELF: And still I
 Why did I
 Him working in the fields while we
 Oh
 My husband in the fields
 He sings
 He sings while we
 ISN'T THAT TERRIBLE SINGING WHILE WE
BOX: Excuse me
 (*They all turn to the stranger.*)
 I did knock
 (*They cease sobbing.*)
 First at the gatehouse

And then here
Quite hard knocks
(*He smiles. He is surprised to see SHELF run past him and out.*
After a fractional pause, COOTER dashes in pursuit...)
I seem to have
(*He sees that LOFTUS stares after them with narrowed eyes.*)
Oh dear

Scene 4

BOX walks further into the room.

BOX: Priests and women
Oh dear oh dear
Is there a seat
They're only human some would say
But if they're only human why are they priests
Priests
Whilst human
Are only priests so long as they abolish much that
constitutes humanity
And subsequently are either more or less than human
But either way
Not quite human
I'd say
There isn't a seat is there
I can't help thinking my visit comes as a surprise
But you were notified
RAGMAN: Our secretary is
We
At the present time we
LOFTUS: The secretary died
RAGMAN: And consequently we are overwhelmed with
LOFTUS: Died and we have still to make appointments to this
and many other posts
BOX: I encounter this wherever I
LOFTUS: It's scarcely a priority of ours
BOX: This cock-eyed
LOFTUS: Not a priority at all

BOX: Lack of management

LOFTUS: Our priorities are strictly defined

BOX: Are they

In some places the tenants are twelve years in arrears

LOFTUS: Fifteen here you'll find

BOX: Hilarious

I must have a seat if you don't mind

LOFTUS: The chapter has no seats

BOX: No seats in the chapter house?

LOFTUS: Not now

Abbot Ragman believes that monks should stand

Stand for business

Kneel for prayer

BOX: That keeps business brief I daresay

LOFTUS: It does

Which

Since the monastery is not a business

But a place of prayer

Is proper surely

(*Pause. BOX looks at LOFTUS a long time. He then looks at RAGMAN.*)

BOX: How old is he?

(*RAGMAN looks uncomfortable.*)

Incredible

(*He shakes his head, smiling.*)

Well

I can stand as long as necessary

What you will find I never do is kneel

I'm Box

Daniel Box and a Crown Commissioner

The document which no doubt still lies on your doormat underneath a heap of love letters says I am visiting and you must render me assistance provide accounts for my examination accompany me on tours of inspection and broadly speaking give me lunch don't say you eat lunch standing up

(*He looks at LOFTUS a long time.*)

It's over, this

(*Pause.*)
Eight hundred years they say
(*Pause.*)
I say eight hundred years so what
(*Pause. He has moved and looks out of the windows.*)
Where's the refectory?
(*Pause.*)
RAGMAN: (*Discomforted.*) The
BOX: Refectory?
Where is it?
RAGMAN: The
BOX: According to my plan it's
(*RAGMAN looks with desperation to LOFTUS, who merely walks a few paces away. BOX interprets for himself.*)
It's gone
(*RAGMAN looks at the floor.*)
You've sold the stone
(*BOX affects dismay.*)
And people say the government's unscrupulous
(*He shakes his head.*)
The monks themselves
They've gone to market with their stuff
(*RAGMAN suddenly weeps. LOFTUS looks at BOX.*)
LOFTUS: Your life's in danger
BOX: Is it?
LOFTUS: I think so yes
BOX: From whom?
(*LOFTUS is running his hands over his cassock.*)
From you?
LOFTUS: I don't know but I think
BOX: Are you threatening me?
LOFTUS: I think if you came back tomorrow
BOX: I can't do that
LOFTUS: Can't come back tomorrow?
BOX: Nope
LOFTUS: Then take a walk
BOX: Take a walk?
LOFTUS: See the place from outside

BOX: I did all that before I knocked

LOFTUS: Oh

Then

Oh

I

(*He starts to writhe. BOX observes him.*)

BOX: Abbot

(*RAGMAN has not observed this tension in LOFTUS.*)

Abbot

(*RAGMAN looks up. BOX indicates with a nod the condition of LOFTUS.*)

I'll come back

(*BOX goes out, unhurriedly. RAGMAN takes LOFTUS in his arms.*)

RAGMAN: What?

What?

(*LOFTUS takes deep, unearthly breaths. RAGMAN supports him in his crisis. He recovers. He stares at RAGMAN.*)

LOFTUS: I must

In everybody's interest I must

AND IT'S DIFFICULT I AM SO YOUNG

Must

Stop

Hating

(*A voice calls off, alarmed.*)

But what if this hatred is inflamed by God?

Is in effect

GOD'S OWN HATRED

(*Another cry. RAGMAN peers at LOFTUS.*)

What if I am

So to speak

ELECTED

To be the bearer of God's hate?

(*COOTER enters, a hand limply raised.*)

To attempt to eradicate what might be

However burdensome to me

Still the will of God

To cleanse my soul as one might strip the backbone from a fish

Surely would cause Him grave offence?

(*He stares at* RAGMAN. *His gaze is drawn by* COOTER.)

COOTER: A man
 (*He jabs his finger.*)
 Out there
 A man
 SMACK
 Face down on the paving
 SMACK
 (*He shakes his head… Pause.*)

LOFTUS: But I never touched him
 (*He looks at* RAGMAN, *aghast, then at* COOTER.)
 SMACK WHAT DO YOU MEAN SMACK

COOTER: Dead

LOFTUS: HOW CLOSELY DID YOU LOOK
 (*COOTER shrinks at* LOFTUS' *vehemence.*)
 Dead
 People cry dead with such alacrity
 As if it gives them pleasure to announce it
 Someone trips
 Someone drinks too much
 DEAD
 DEAD
 THE CRY GOES UP
 Not everybody's dead who happens to be still

COOTER: LOFTUS I EXAMINED HIM
 (*A long pause…*)

RAGMAN: Of course he's dead

LOFTUS: Yes

RAGMAN: We both know

LOFTUS: Yes
 We do know
 (*He suddenly falls to his knees, as if swooning.*)
 OH LORD GOD
 OH CHRIST AND FATHER WHAT HAST THOU
 (*With a peculiar cry* RAGMAN *finds himself driven to run about the room.*)

RAGMAN: Go, Anthony

LOFTUS: OH WHAT IS THIS TERRIBLE ENDOWMENT

WHAT IS

WHAT IS THIS

RAGMAN: (*Running in circles.*) GO I SAID

LOFTUS: MONSTROUS POWER YOU HAVE LAID IN ME

 (*COOTER, horrified by this spectacle, takes to his heels.*)

 Relieve me

 Oh

 Relieve me

 I AM SHALLOW FICKLE POOR

RAGMAN: Lord God help us lift lift thy curse from this

 exquisite and impetuous youth thy servant thy

LOFTUS: POOR

 POOR

 POOR

 (*LOFTUS beats the floor with his hands. RAGMAN runs and runs.*)

RAGMAN: Thy devoted servant in whose eyes the light of faith

 burns fierce as

LOFTUS: TOO POOR FOR SUCH

RAGMAN: Furnaces and whose mouth teems with words of love

LOFTUS: ONEROUS

RAGMAN: Spilling

 Cascading

 Epithets of

LOFTUS: RESPONSIBILITY

 (*Both RAGMAN and LOFTUS are exhausted, still, horizontal. They
do not move for some time. Then LOFTUS drags himself back onto
his knees.*)

 Certainly I must go easy with it

 (*Pause.*)

 I can't just

 (*Pause.*)

 For example

 Take against the milkman

 (*He cannot help laughing.*)

 Just because he's late with the deliveries

 (*He laughs loudly…goes still again.*)

RAGMAN: How exquisite my life was

 Sinful

Godless
Always Autumn
Sweet with smoke and apples
Sometimes I stripped naked to eat dinner
Alone with my own body
Red wine
Burgundy
Fine glass
Venice
And on the blushing carpet
Persia
Spread my fat arse
Staring at the putti in the ceiling
Milan
(*He laughs.*)
Owls carving the valley on white wings
The river gossiping as it raced beneath my bedroom
LOFTUS
HOW WRONG IS THE BEAUTIFUL?
(*Pause. LOFTUS climbs to his feet.*)
LOFTUS: I find God mischievous
(*He bites his lip.*)
How terrible to say so but I must
(*Pause.*)
I must in the certain conviction that prayer and further
meditation will reveal this to be a misapprehension on my
part
(*Pause.*)
Far from mischief it will be seen to be oh
(*Pause.*)
I don't know what
(*Pause.*)
But at the moment it seems like mischief
(*Pause.*)
For example
This power He has bestowed on me
(*Pause.*)
This
WISHING PEOPLE TO DEATH

(*Pause.*)
If God hates
And we know He does
HATE SO EXTENSIVELY
Why does He not
On His own account
Simply
(*He shrugs.*)
Remove from them the life He gave them?
(*Pause.*)
Why me?
(*RAGMAN lifts himself up, sitting on his haunches.*)
I am barely seventeen
I come to serve God
I pray at all hours
I feel however wrongly some proximity to Him
And I am suddenly
THROWN DOWN
As if by a wave which lurches out of an apparently tranquil
sea
When others
Probably more equipped than I
RAGMAN: No
(*Pause.*)
LOFTUS: No?
RAGMAN: No one
(*Pause.*)
No one more equipped than you
(*Pause. LOFTUS walks, thinks, concludes.*)
LOFTUS: I'm chosen, then?
RAGMAN: Yes
(*Pause.*)
And I
A bit sinful
A bit Godless
But an abbot all the same
I was chosen also
But chosen only to
Acknowledge you

(*LOFTUS runs to RAGMAN and embraces him.*)
Yes
Yes
(*They laugh with pleasure.*)
LOFTUS: Oh live
Live forever dear one
RAGMAN: I'll try
I'll try

Scene 5

A wealthy woman enters.

FELLOW: I've a carriage up the drive and the coachman wants
his breakfast I said monks are famous for their hospitality so
if you see a man in pink poking about he's only looking for
what do you call it I said the refectory bacon and eggs he
wants is it the refectory?
LOFTUS: Yes
FELLOW: Of course it is
(*Pause.*)
LOFTUS: However he won't discover it
The refectory has been demolished and the sandstone is
I regret to say
Incorporated into someone's house
FELLOW: But your appetites were not extinguished with the
building I daresay?
(*LOFTUS looks coolly at FELLOW.*)
The monks still eat?
(*LOFTUS declines to reply.*)
He'll turn up something and if he doesn't
(*Pause.*)
Let him starve
(*Pause.*)
I am trying to be amusing and making rather little progress
my husband dropped dead at your feet that perhaps
amused you he had come to close you down
(*Pause.*)
LOFTUS: Not at my feet

FELLOW: Not at your feet exactly how cold and pedantic you
 are not the abbot's feet either but everyone says the pale
 youth is the abbot ignore the actual abbot
 (*Pause.*)
LOFTUS: There is one abbot here and only one
FELLOW: Father Ragman but I go straight to the top sometimes
 the top is the bottom still that's where I go
 (*Pause. She laughs.*)
 Such hard work with you
 I spoke to the monk Anthony he was sedulous and pointed
 to the very stone my husband died on he saw the whole
 thing Anthony he ran he called he lifted him I had to see
 the spot Anthony said if I wanted I could have the stone
 it must weigh a ton but the coachman is a brute he could
 lever it but I would need permission from the abbot a
 formality said Anthony but looking at you I'm not so sure
 (*Pause.*)
LOFTUS: Indeed we are reluctant to
 I am particularly
 Reluctant to see the fabric of the abbey carried off
 For piety or profit
 (*Pause. They both begin to laugh. They shake.*)
 I don't know why I
 I don't know why I'm laughing
 Nothing
 (*He struggles to control himself.*)
 Nothing you have said is
FELLOW: No
LOFTUS: Is it
 Remotely funny
FELLOW: No
LOFTUS: On the contrary
 (*The tears stream down his face.*)
 Did you not love your husband then
 I
 I
 (*He erupts again.*)
FELLOW: No I didn't but
 Since you ask but it is not so simple is it

LOFTUS: I don't know I
FELLOW: I
>There are no seats here
>(*She casts about for a place to recover.*)
>No seats in the chapter house
LOFTUS: That's what he said
>The same words exactly
FELLOW: NO SEATS IN THE CHAPTER HOUSE
LOFTUS: Forgive me I
>(*He draws deep breaths. He is still.*)
>Forgive me
>(*He wipes his cheeks with his cuffs.*)
>I never laugh
>(*Pause.*)
>And that
>(*Pause.*)
>Hurt me
>(*Pause.*)
>I thought for a moment I might die
>(*He stares at FELLOW.*)
FELLOW: Yes
>It can be frightening
LOFTUS: I thought
>For one moment I thought
>(*It overcomes him again. This time she watches with some alarm.
>LOFTUS battles with his own laughter, moving over the floor,
>holding himself, throwing back his head. FELLOW turns away, as
>if embarrassed. At last it subsides again. He wants to speak but
>dares not utter. He moves a hand in the air. He disciplines himself
>as if he were his own animal.*)
>Can I be of any further assistance to you?
>(*He is able to face her.*)
FELLOW: Show me yourself
>(*Pause.*)
LOFTUS: You
>(*Pause.*)
>You think me hidden and
>(*Pause.*)

Obscure possibly but it's my way always I was taciturn
preferring a few words carefully chosen to a flood of
approximations

FELLOW: Naked

(*Pause.*)

I meant naked

(*He looks coolly at* FELLOW.)

If you will be naked so will I

(*Pause.*)

I'm neat

(*Pause.*)

Four pregnancies and still

(*Pause.*)

Girl-neat

(*Pause.*)

Girl-perfect

(*Pause.*)

LOFTUS: I sometimes think God called me not at all for my
own salvation but for the salvation of the priesthood so very
low is the priesthood so smeared and faithless it comes as
no surprise to me than an educated woman might expect a
priest to welcome such an invitation the fault lies with the
priesthood surely

FELLOW: Four pregnancies and none I'm certain from my
husband

(*Pause.* LOFTUS *knits his brows.*)

LOFTUS: I am at a loss to understand why you advertise
your misdemeanours when a man made party to such
information far from inclining to you must recoil surely?

FELLOW: Are you recoiling?

LOFTUS: Yes

Oh yes I am

FELLOW: Then I made an error

(*She looks down.*)

I hoped to be liked by you

And hoping to be liked I wished to indicate that whilst
being naked with a stranger might be a cause of some

anxiety to you I myself was not unfamiliar with such
collisions collisions I call them I was however
(*Pause.*)
In this instance
(*Pause.*)
Badly mistaken
(*Pause.*)
I would have done better to address myself to Anthony but
Anthony did not move me
(*She goes to move, stops. She goes to strip her garments.*)
I CANNOT LEAVE THIS PLACE UNTIL
(*LOFTUS makes to flee.*)
DO NOT LEAVE
(*He stops.*)
IF YOU WILL NOT
I MUST BE
(*She tears away her clothing.*)
STARE
STARE
AT ME
(*She stands in the ruins of her clothes. Her own eyes are closed.
LOFTUS looks. FELLOW opens her eyes at last.*)
I feel better
I do
Feel so much better for that
(*Pause. She draws up her clothes swiftly, her fingers nimble but
nervous.*)
Think
If you prefer it
My husband's death and my proximity to the location of it
created a delirium in me
It isn't true of course
It's you
Don't ban me from your sight will you?
(*LOFTUS does not reply. FELLOW walks out. LOFTUS falls to the
floor. He arches. He endures an attack.*)

Scene 6

LOFTUS lies on his side, infinitely still. Suddenly he sits up.

LOFTUS: That was not sickness
 (*Pause.*)
 That was an exquisite reproduction of my sickness
 (*Pause.*)
 The fact is my sickness no longer visits me
 Yet I require a sickness
 Why?
 (*A figure lurches in, clutching his jaw.*)
 Anthony
 Sit and speak with me
 (*COOTER ignores LOFTUS. He staggers, retching.*)
 I have discovered falseness in myself
 (*COOTER lurches out as SHELF hurries in.*)
 Falseness which serves presumably to
SHELF: They hurt him
LOFTUS: To compensate me for some failure to
SHELF: Loftus
 They hurt him
 (*She hurries away in pursuit of the injured COOTER. LOFTUS climbs to his feet and is about to go to assist them when a third figure enters and follows in pursuit of SHELF.*)
LOFTUS: Hey
EXX: Nothing hey
 (*He is undeviating.*)
LOFTUS: HEY I SAID
EXX: (*Turning on his heel.*) I KILL PRIESTS
LOFTUS: (*Shocked.*) That's
 That's
EXX: (*Shoving LOFTUS in the chest.*) Shut up you slice of filth
 (*LOFTUS staggers, regains his balance.*)
LOFTUS: You may not violate these premises
EXX: (*Returning.*) AND MY PREMISES WHO MAY VIOLATE
 THEM SLICES OF FILTH MAY AND MY WIFE WHAT OF
 HER PREMISES HER SHIT HER PISS ALL OVER HIM I KILL
 PRIESTS

It's not right is it
Is it right
(*He sobs.*)
I come home singing sometimes singing and she at the oven
her arse in the air bending to the baking is it right this arse
in the air I kill priests I kill them
(*He shakes with grief, his shoulders fall...*)
I know you
You are the good one
The good one is but one however isn't he?
(*Pause. EXX is in two minds whether to pursue his wife or not. He goes a few paces and returns. He hangs his head a moment, and then goes slowly by the way he came.*)

LOFTUS: Continue to sing
(*EXX stops.*)

EXX: Sing?
While he
While she
Her arse licked and me singing?
(*He laughs, bitterly, jabs a finger at LOFTUS.*)
You sing

LOFTUS: It's a matter of
(*Pause.*)
Standing away from a thing
(*Pause.*)
Not parting with your pain because pain can't be parted
with but
(*Pause.*)
Watching it
(*Pause.*)
And singing
(*Pause.*)

EXX: Funny singing that would be

LOFTUS: Loud
Loud singing
(*EXX goes out... LOFTUS surges with a rage.*)
BRING HIM
BRING ANTHONY

(*He shouts off.*
RAGMAN enters, perplexed.)

RAGMAN: His jaw is broken

LOFTUS: Excellent

BRING ANTHONY

SHELF: (*Running in.*) His jaw is all

LOFTUS: I know about his jaw

FETCH HIM

(*SHELF sobs and runs off again.*)

RAGMAN: I think

When one is exasperated

When one is bathed in indignation

LOFTUS: You deal with him

RAGMAN: That is not the proper time to issue binding and

LOFTUS: I SAID YOU DO IT

(*SHELF comes back in ashamed.*)

SHELF: It's me

It's me and only me

LOFTUS: It isn't you

SHELF: So often he has closed his eyes to me

LOFTUS: It isn't you I said

SHELF: Covered his eyes with his hands while I paraded naked
and

COOTER: (*Entering nursing a bandaged jaw.*) Mm?

(*COOTER affects a casualness.*)

LOFTUS: She says it's her but it's not her it's you

COOTER: Mm?

LOFTUS: Isn't it she did not swear to celibacy did she whereas
you

(*He nods to RAGMAN.*)

Go on

(*LOFTUS strides away and turns the room.*)

RAGMAN: (*Lifting a hand vaguely.*) I feel

I know

The weakness of each one of us when confronted with

LOFTUS: We've been through this

RAGMAN: The susceptibility of every man to

LOFTUS: A priest is not a man

(*RAGMAN casts a glance at LOFTUS.*)
Is he?
Go on
RAGMAN: The susceptibility even of an individual sworn to a
 life of spiritual exigency when on occasion he is exposed to
LOFTUS: THOSE ARE THE OCCASIONS THAT MATTER
RAGMAN: Yes
 Yes
LOFTUS: We must move on from this
 This
 SHARING
 AND FORGIVING
 (*He turns abruptly to COOTER.*)
 Anthony
 Collect your things
 (*COOTER looks aghast.*)
 He must go mustn't he he must
RAGMAN: WHO IS THE ABBOT HERE
 WHO
 WHO
LOFTUS: He must go
RAGMAN: (*Seething.*) You come here
 You come here with this juvenile and preposterous
 affectation of
LOFTUS: Anthony
RAGMAN: Of
 Of
 Piety
LOFTUS: Anthony
RAGMAN: Claiming
LOFTUS: What
 What did I claim?
RAGMAN: Claiming entrance to the congregation of this order
LOFTUS: Anyone may claim that
 Anthony
RAGMAN: Claiming
LOFTUS: (*Piqued now.*) I CLAIMED MY UNION WITH GOD
 Anthony

You are smiling
Even through a fractured jaw smiling
Does it amuse you to hear me attacked?
Does it amuse you that Roger can describe my love of God
as a preposterous affectation?
Perhaps you think it is a preposterous affectation also?
RAGMAN: Did I say that?
I didn't mean to say that
LOFTUS: You did say that
Is it amusing that we two
The last of this order should be reduced to making such
savage and unwarranted attacks upon each other?
Is that amusing?
COOTER: Yes
LOFTUS: It is is it?
COOTER: AMUSING YES IT'S FINISHED ALL OF IT DONE IN
DONE UP DONE DOWN YOU ARROGANT AND
I PISS ON YOU
Oh my jaw is
PISS
PISS ON YOU
Oh
(*He is nauseated by a wave of pain. A pause. He holds his head...*)
I have a feeling
A terrible feeling
(*He winces.*)
That people like you must exist
If only to
Oh
(*Pause.*)
If only to remind us how beautiful life is
YOU HATE LIFE
(*A wave of pain.*)
Oh
HATE
LIFE
OH
(*SHELF stretches a tender hand.*)

SHELF: Shh
 Shh
 (*A table of infinite simplicity is drawn in. Two wooden bowls
 stand on it. COOTER, followed by SHELF, leaves.*)

Scene 7

*RAGMAN and LOFTUS go to the table. They kneel at either end. They
separately pray. A wind causes a distant door to repeatedly crash. They
begin to eat from the bowls. After a time, LOFTUS gets up, goes out. He
returns, having fastened the door. He resumes his kneeling position. He
picks up his spoon. He eats. He is slowly made aware that no sound comes
from RAGMAN's spoon. He looks across the table. RAGMAN is looking
into his bowl but is motionless.*

LOFTUS: This wind
 (*Pause.*)
 I think sometimes if the wind is bad here bad in this valley
 (*Pause.*)
 How much worse it must be
 (*Pause.*)
 At sea or
 (*Pause. LOFTUS is staring at RAGMAN. He knows but he persists.*)
 I have always thought to reach God one must walk in
 barren places
 (*Pause.*)
 The wilderness
 (*Pause.*)
 The rock
 (*Pause.*)
 I can't help thinking that in siting the monastery here our
 predecessors themselves began that process of decline that
 we are heirs to they were ravished by the beauty of this
 valley the river and the pasture their first thoughts directed
 not to God but to their own convenience from that all
 subsequent corruption surely flowed
 (*Pause. LOFTUS rises to his feet. He places his spoon in the empty
 bowl and going to RAGMAN, puts his bowl inside the first. He goes
 out. Very distantly LOFTUS can be heard singing. The loose door
 begins to swing again. LOFTUS appears again. He is still.*)

I wanted to wash up
(*Pause.*)
I did not want my concentration spoiled by some nagging
sense that in another room was waiting this
(*Pause.*)
Greasy bowls and so on
(*Pause. He sits on the table. He hugs his knees.*)
When I saw that you were dead for one brief moment I
thought
OH DID I HATE HIM WITHOUT KNOWING IT?
(*He rocks to and fro.*)
But worse than that supposing you
As death came up to you
As death laid his hand on your shoulder
Supposing you thought
LOFTUS HAS WISHED MY DEATH ON ME?
(*He turns to the body of RAGMAN.*)
No
No
Never
Never
Believe me
(*The door irritates LOFTUS.*)
I latched that door
I latched it
(*He jumps off the table. He walks out bad-temperedly. After a
moment, his terrible cry is heard. Two hooded men enter dragging
LOFTUS between them, a hand over his mouth. They hoist him
bodily over the table, face-down.*)
FIRST INTRUDER: He's fucking you
(*With a cry, LOFTUS' head is shoved over the rim of the table.
The shock of the movement dislodges the body of RAGMAN from its
posture and his head falls forward onto the table.*)
And he can't look
(*LOFTUS is sodomized. The intruder races to his ecstasy.*)
HE CAN'T LOOK
(*The act completed, the FIRST INTRUDER climbs off the table. He
cuffs the back of RAGMAN's head.*)
Look now

LOOK

THEN

(*The intruders stagger out. LOFTUS in his agony does not move.
The unlatched door continues to swing. After a long pause, LOFTUS
raises his head.*)

LOFTUS: Lord

The desecrators of thy house

AND OF THY SERVANT'S FLESH

Lie dead surely

Surely

Surely

They

Lie

Dead?

(*To his horror, the intruders lurch back into the room. The SECOND
INTRUDER returns to LOFTUS.*)

FIRST INTRUDER: Oh fuck

He's doing you again

(*The SECOND INTRUDER thrusts his hand over LOFTUS' mouth
and proceeds to sodomize him again. LOFTUS utters.*)

LOFTUS: Father

This is not hateful to you then

(*He screams his pain.*)

HE HEARS ME

AND IT IS NOT TERRIBLE TO HIM

Scene 8

An elegant official enters, transporting a chair in one hand.

COTTON: (*Placing the chair.*) Brought my own chair

(*Pause. LOFTUS' manner is chill. COTTON leans on the back of the
chair.*)

Brought my own cook

Butler

Swordsman

A little army coming down the hill to plague the unswept

cloister

Bottled water also

I don't share streams with cattle

Shall I sit

This is vastly bigger than expected as it loomed into view I
swiftly revised my estimate

(*He sits.*)

Not of its value

But of the time required to value it

(*Pause.*)

And only you remaining

(*Pause.*)

Only you

(*Pause.*)

LOFTUS: How hard it is to discern the will of God but harder
still to gauge His resentment

(*Pause.*)

Some acts arouse His wrath

(*Pause.*)

But others

(*LOFTUS shrugs.*)

It is as if He kept His eyes averted

COTTON: Yes

LOFTUS: Swift to punish on the one hand and then

(*Pause.*)

Oddly complacent

(*Pause.*)

COTTON: Possibly

(*Pause.*)

LOFTUS: One cannot resist the desire to comprehend the will
of God but it remains outside the realms of comprehension
and for the very good reason that were it comprehensible
God would cease to be Himself. He would cease to be God
and become human.

COTTON: And are humans not incomprehensible?

(*Pause.*)

LOFTUS: No

They are forever comprehensible

It is their pathos and their tragedy

(*Pause.*)

COTTON: Well, there is no mystery about me

I am the Crown Commissioner
The last one suffered a stroke I understand here on the
premises
LOFTUS: Outside the door
COTTON: This door?
LOFTUS: The same door
Smack he went
I didn't see
COTTON: The consequences of excessive standing presumably
LOFTUS: His wife came on a pilgrimage
COTTON: Did she?
LOFTUS: She stood where he stood
The same pavement
Are you married Mr Cotton?
COTTON: I am married but I don't think you will need to
console a second widow I have brought a chair
LOFTUS: Men die sitting Mr Cotton
COTTON: Yes
LOFTUS: And horizontal too
COTTON: They do
They die in all sorts of postures
Are you never lonely here?
LOFTUS: Never
COTTON: It's huge
LOFTUS: In comparison with what?
COTTON: With anything
Huge
And
Embarrassing
LOFTUS: I am not embarrassed
COTTON: Are you not?
(*Pause. COTTON tips the chair on its back legs, his hands folded on his stomach. The two contemplate one another for some time.*)
I'm not well
(*Pause. He allows the chair to settle on its legs again. He is alarmed.*)
I'm not well

LOFTUS: (*In an ecstasy.*) Now this is peculiar
OH LORD PECULIAR
(*He turns away and flings himself down, facing away from the stricken COTTON.*)
COTTON: NOT WELL I SAID
(*He crashes off the chair and sprawls.*)
LOFTUS: (*COTTON emits profound groans.*) For thou wilt bring crashing to the ground these paper men yet spare the brutal interlopers who broke into my arse
(*COTTON dies.*)
I FATHOM
I FATHOM
THEE
I DRAG THY DEPTHS
(*He agonizes. He climbs to his feet, he looks at the body of COTTON.*)
God hated you
Whereas in this instance I did not
(*LOFTUS crouches beside COTTON, biting his lip as he studies.*)
I hated the violators of my flesh
But God did not
(*Pause. He aches.*)
What can this mean but that God wished my agony on me?

Scene 9

A woman in mourning. She looks at LOFTUS. LOFTUS erupts into laughter. She waits, mildly irritated as he struggles to control it.

LOFTUS: (*At last.*) The abbey cannot be dismantled
At least not so long as
(*His laughter overcomes him again. He fights it back.*)
I
Am
In
It
It
Appears
(*He presses his lips together. Pause.*)

BATH: I did not love my husband
LOFTUS: They all say that
(*He breaks out in laughter.*)
WHY DO THEY ALL SAY THAT
(*He shakes his head as the laughter recedes.*)
It is as if
Following on from sudden death comes a painful
illumination
BATH: Yes
LOFTUS: Dawn filtering beneath the blind
BATH: Yes
LOFTUS: Greasy dawn not very welcome
BATH: Yes
Exactly how I would say it
If I could say it
(*Pause.*)
But truth is
(*Pause.*)
Or what presents itself as truth
(*Pause.*)
Is only the threshold to a further corridor of lies I find
(*LOFTUS examines her. He bursts out laughing again. He thumps
himself on the chest, the knees...*)
Undress then
BATH: Undress?
LOFTUS: (*Choking.*) Be naked yes
(*He swallows the laughter at last.*)
BATH: How did you know that I wished to be
LOFTUS: Oh
Oh it's
(*He closes his eyes.*)
I didn't know
(*Pause. BATH begins to strip her garments. LOFTUS hears this. She
unbuttons her bodice. She stops.*)
BATH: Please look on my breasts
(*He shakes his head.*)
LOFTUS: I
BATH: KILLER OF MY HUSBAND LOOK AT MY BREASTS

(*Pause. LOFTUS opens his eyes.*)

LOFTUS: I did not lay one finger on your husband
 Nor did I utter any unkind word

BATH: You killed him

 (*LOFTUS inclines his head patiently.*)

LOFTUS: God took his life away

BATH: YES
 ON YOUR INSTRUCTION
 (*Pause.*)

LOFTUS: I?
 I instruct God?
 (*Now he pretends to laugh.*)
 No
 How false that laughter was
 I
 I was attempting to conceal
 ALWAYS I CONCEAL
 To conceal my serious consideration of your proposition
 HOW CAN THE SERVANT POSSIBLY INSTRUCT THE
 MASTER
 He would become the master
 (*She looks coolly at LOFTUS. LOFTUS walks a little, his hands
 together. He stops.*)
 Obviously one must consider all propositions however
 absurd repellent or mischievous they appear to be what
 kind of priest would I be if in an entirely prejudicial way
 I banned all argument ex officio de principe and so on no
 how strange I was looking for a chair!

BATH: There are no chairs here

LOFTUS: No
 (*He looks at BATH. Pause.*)
 Very well
 Let us interrogate
 If only for the exercise
 An intolerable idea
 The idea that God has delegated to a humble and ill-
 educated
 Please

Your breasts
Do you think your breasts should be
BATH: Just such a humble and ill-educated priest
LOFTUS: Not yet a priest a novice
BATH: Just such an individual God would choose
 (*Pause.*)
LOFTUS: Yes
 Yes
 His way precisely
 But that only draws us deeper in
 Very well
 Leave your nakedness
 Let it be said of Loftus that he stood in ponds of scented
 flesh and still
 STILL ARGUED GOD
 Show your arse for all I care
BATH: You do care
LOFTUS: I DO CARE AND I OVERCOME IT
 (*He glares at her.*)
 No
 We are drawn to the greater and more terrible question
 WHAT FATIGUE IN GOD CAUSED HIM TO WILLINGLY
 SUBORDINATE HIS POWERS?
 (*Pause.*)
 I seem to have answered that
 (*Pause.*)
 Fatigue itself
 (*Pause. He looks at BATH.*)
BATH: There you are, then
 (*Pause. He mimics her.*)
LOFTUS: There you are, then
 (*He laughs.*)
 THERE YOU ARE, THEN
 (*He spins on his heel.*)
 If this is so
 If this
 Any of this is so
 HOW DID I

SINCE I COMMAND GOD
HOW DID I PERMIT TWO THIEVES TWO SWINE TWO SCUM
WHO BROKE IN HERE TO LIVE I SEARCHED THE GARDENS
FOR THEIR BODIES NONE NO BODIES ANYWHERE
(*He looks at BATH.*)
Your husband expired there
Some sound came from his throat
If it was painful it was brief
(*With an unearthly cry, lingering, fluctuating, LOFTUS bends, picks up the hems of his cassock and lifts it high.*)

Scene 10

A man enters, a briefcase in his hand.

BIRO: Let's talk about your pension
(*Pause.*)
Given your age
(*Pause.*)
And your lack of qualifications
(*Pause.*)
What is on offer here
(*Pause.*)
And I'm not given to exaggeration
(*Pause.*)
Is quite fabulous
(*BATH and FELLOW, dark grey in dress from head to foot, enter and take up station. BIRO observes them, and perseveres.*)
It's to do with the number of priests novices and lay
brothers on the roll of every monastery multiplied by six
why six don't ask me and then the square of that divided
but not equally of course there are factors such as seniority
and long service here however there is only you the first
payment comes on the fifteenth of this month it may seem
silly talking pensions when you have barely had your
nineteenth birthday probably you're thinking of your next
career school-teaching or some go straight to Rome the cost
of living there is only a fraction of
(*He stops. He looks at LOFTUS.*)

LOFTUS: I'm ill, you see
 (*Pause.*)
BIRO: You should have said
 This may entitle you to further benefits
LOFTUS: By ill I mean I am not modern
 (*Pause.*)
BIRO: And that's an illness, is it?
LOFTUS: It is the next thing to being dead
 (*BIRO smiles politely.*)
BIRO: The dissolution of the monasteries has proved extremely
 popular
 (*Pause.*)
 All these bricks
 (*Pause.*)
 All this timber
 (*Pause.*)
 Rotting in the winter winds
 (*Pause.*)
 Splitting in the heat of summer
 (*Pause.*)
 Waste
 (*Pause.*)
 Appalling waste when people are
LOFTUS: Shh
BIRO: In such bad housing and
LOFTUS: Shh
 (*Pause.*)
 This illness takes the form
 On the one hand
 Of blindness
 Blindness to self-interest
 (*Pause.*)
 On the other
 It's a fever
 Your skin burns in the presence of liars
 (*Pause.*)
BIRO: (*Cautiously.*) The figures are perfectly correct I promise
 you

LOFTUS: I don't doubt your accountancy
(*Pause. BIRO shifts.*)
BIRO: You only need to sign and
(*Pause.*)
Or not sign and
LOFTUS: The fatigue of God far from relieving us of our
responsibilities places us under a yet greater obligation just
as in a family the sickness of the father or the mother whilst
it may appear to threaten order and tranquillity only serves
to accelerate the active participation of the children in the
adult world they who previously looked to the parent for
every moral precept and practical advice must prematurely
perhaps choose act and discriminate on their own account
(*BIRO falters...*)
BIRO: If you sign now I can have the papers in the office by
Monday
(*Pause.*)
Alternatively if you don't require a pension you will need
to sign a form called a disclaimer a disclaimer as the name
suggests
(*He sways a little...*)
I had heard of these two Mr Box and Mr Cotton how they
came here in perfect health and in good weather thinking
quite ordinary things and dying suddenly it gave me pause
for thought no one willingly exposes himself to danger what
danger though why danger how does it threaten anyone to
give them money?
(*He fails to laugh.*)
All the same I gave my children such a hug which normally
I never do
(*He is pale with apprehension.*)
Let me walk out
(*LOFTUS is equally strained.*)
Please
(*They suffer, then LOFTUS rushes from the room. BIRO, with a
glance at FELLOW, takes to his heels. BATH wanders idly to the
door, studying his departure. LOFTUS returns, vigorously towelling
his head.*)

LOFTUS: I plunged my head under the tap cold water rinsed
my brain all temper gone antagonism washed away
(*He stops.*)
Of course it may be too late
He may be already dead
He may be at this moment as I speak
(*FELLOW draws LOFTUS into an embrace, smothering his mouth
with hers. His hands rise, empty. He frees himself.*)
At this moment flapping on the ground
A stranded fish
A shot bird
(*FELLOW kisses him again. Again LOFTUS frees himself.*)
I hear his orphaned infants wail I hear their widowed
mother beat the floor
(*Again FELLOW thrusts herself on LOFTUS. He averts his face.*)
Her fists all
Her nails all
(*FELLOW flings away from LOFTUS. She sits clumsily on the floor,
her legs before her like a doll. LOFTUS looks at BATH.*)
I do not kiss
Her tongue invades my mouth
And when her hands like hounds run over my arse
Whilst I go stiff
It is no more than
What
The petals of a flower opening to the sun
(*She looks coolly at him. A prematurely aged woman appears in the
door. BATH observes her, and leaves. LOFTUS appears thoughtful,
contrite.*)

Scene 11

LOFTUS: He died then?
(*The woman meets his gaze.*)
How can I say I'm sorry when
(*His look is eroded by a smile.*)
When
OH GOD OH CHRIST THIS

(He begins to laugh. His body shakes. He fights the laughter, grasping his torso in both hands, walking away, clasping himself about the neck, bending from the waist. At last it subsides...)

I did not hate the insurance man

(Pause.)

Possibly however

(Pause.)

I required his wife

NAPE: Bring him back for me

LOFTUS: *(Puzzled.)* Bring him back?

(He frowns.)

But I'm here

(He examines her.)

Your eyes are razors in a mask of stone your hips are knives how does your skirt cling without shredding on the bone this is not grief it is the chill draught of an unexpected solitude it goes ask her it goes the wailing of your orphans deafens you to the music of a cleaner life perfectly dead is your husband perfectly home is abolished home is me

(NAPE is engulfed by apprehension.)

NAPE: I am the wife of the insurance man I am not clever did I say wife I am the widow of the insurance man and I

LOFTUS: ALL THIS I AM NOT CLEVER

ALL THIS I AM SO SAD

(She flinches.)

It's nakedness

It's bed

(NAPE is intimidated. She hangs her head. BATH goes to her and placing an arm around her shoulder, leads her away. LOFTUS is still. He hears NAPE wail. He frowns. He kneels. Slowly his head tips forward until it touches the stone. A figure enters and observes him.)

COOTER: I bought the floor

(Pause.)

The thing you're spread over I own it

(A dread suffuses LOFTUS. Slowly he comes upright.)

Does it smell of us I wonder does it cling the odour of dead priests their rotted rages and the sour stink of celibacy I

hope not I have four thousand tons of this to furnish manor
houses with
(*He taunts LOFTUS.*)
the swish of party dresses
the trip-you-up of children's toys
spoiled children
inconstant wives who want a hundred bedrooms for their
acts
(*He stares.*)
And the roof is also mine
(*Pause.*)
When you arrived here
mincing
pale
with washed out eyes that clung to crevices until provoked
by some casual blasphemy you lifted them smoking like the
mouths of guns to search our brains we might have known
this boy is
GOD'S EXECUTIONER
you're doing it now
your glance is sticking in the back wall of my throat
IT'S RUDE OLD SON
(*Pause. Suddenly LOFTUS launches himself at COOTER and
grasping his hand, inhales the odour of the palm. He recognizes
it…*)
I didn't know what to do with you
I had to do something
I had to
(*LOFTUS is placid, thoughtful. He releases COOTER's hand. He
walks away from him. He turns. He scrutinizes him. FELLOW and
BATH enter, confrontational.*)
FELLOW: We will buy this from you and seal the doors no word
or letter rodent or bird will travel from this paradise to
yours
(*COOTER turns to the women, exquisitely indifferent.*)
COOTER: It can't be done
(*He looks at LOFTUS.*)
With Paradise there can be only one

Yesterday we contemplated God today the drum beats and
you must dance
(*He looks at* FELLOW.)
Those who dislike dancing rock from one leg to the other
or it will be known
(*He starts to leave, and stops.*)
Aren't you mothers mothers and you shack here showing
your pallid arses to the moon mothers and your belly hair is
little fields for him to stroll in convalescing
(*He looks at* LOFTUS.)
I always thought of him as ill the finest minds are ill and
that must be why you have quit your children the greater
child is Loftus
HE STINKS OF YOUR WOMBS
(*The women gaze on him, unrebuked. He leaves, passing* NAPE,
who joins them. The three are drawn, as if by a current, to observe
COOTER's *departure...*)

BATH: His feet are iron
FELLOW: On eggs
BATH: He treads on eggs
FELLOW: With feet of iron
 (*They laugh.*)
BATH: He swerves
FELLOW: He trips
BATH: He grabs his head
FELLOW: (*Triumphant.*) Head hurting
BATH: Stops
FELLOW: Holding his head
BATH: Stops now
FELLOW: And head hurting
BATH: In pain
FELLOW: Or thinking possibly
BATH: Dying
FELLOW: Or thinking
BATH: Awful pain
 (*A shock.*)
FELLOW/BATH: HE'S COMING BACK

(*They frown. They jostle one another in their retreat. COOTER enters, unsteady on his feet. He leans on the door before speaking, a weak smile on his face.*)

COOTER: I'm forgiven then?

(*He lifts his gaze to LOFTUS.*)

This wave of nausea I thought this is the end it wasn't I thought he's killing me you didn't what is it with you and me

STILL ALIVE AND UNREPENTANT OBVIOUSLY

(*Pause. LOFTUS is without anger.*)

LOFTUS: If one enters God one becomes God I can see no other explanation I do not like you Anthony but you participate in my divinity liking or not liking is therefore a supreme irrelevance in this instance and possibly all others I will study the problem of antipathy and abolish it

(*COOTER is bemused. He shrugs, and turns to go.*)

COOTER: This floor sorry I've got a dozen blokes to lift it sorry tomorrow they begin carts and crowbars blaspheming obviously and noise sorry sorry

(*He hesitates, then hurries off. The women look to LOFTUS. He joins his hands together and lowers his head, a sign for them to leave him. They withdraw but NAPE returns and stands gazing at LOFTUS.*)

NAPE: Fuck me

(*He hears but ignores her.*)

Fuck and fuck me

(*He is still.*)

KILLER FUCK ME

(*LOFTUS makes a slight movement with his head. NAPE walks out, strong. LOFTUS contemplates his divinity. He is seized by a thought, and grapples with it. He is shocked and moved by the subsequent appearance of BIRO standing in the door, clutching his briefcase, equally shocked. They exchange a look of profound apprehension. At last LOFTUS succeeds in lifting a finger.*)

LOFTUS: She's down there

BIRO: Thank you

(*BIRO walks in the direction indicated by LOFTUS, whose finger remains suspended. LOFTUS hears the echoing cry of NAPE's shock*)

as her husband encounters her. It is followed by a piercing wail of joy or horror. The wail is itself subsumed in an inconsolable sobbing whose profound melancholy seems to injure LOFTUS. He squirms, and sinking to the floor is overwhelmed by the recurrence of his old sickness. BATH and FELLOW hurry in, stricken and pale with anger. They watch LOFTUS convulse in his ordeal, which subsides with the distant sobbing. He is still. NAPE enters, ghastly and holding a knife removed from the kitchen. By a tacit collusion, the women castrate LOFTUS. They enclose his hips in a towel. They extend his arms. They desert him.)

•

Printed in the USA
CPSIA information can be obtained
at www.ICGtesting.com
LVHW020940171024
794056LV00003B/887